In defence of the media arts

Andrew Burn

In defence of the media arts
Screen education in the twenty-first century

Andrew Burn

Based on an Inaugural Professorial Lecture delivered at the UCL Institute of Education on 18 April 2013

UCL Institute of Education Press
Professorial Lecture Series

HARVARD UNIVERSITY
GRADUATE SCHOOL OF EDUCATION
MONROE C. GUTMAN LIBRARY

Institute of Education

First published in 2016 by the UCL Institute of Education Press,
20 Bedford Way, London WC1H 0AL

www.ucl-ioe-press.com

© Andrew Burn 2013, 2016

British Library Cataloguing-in-Publication Data:
A catalogue record for this publication is available from the British Library

ISBNs
978-1-78277-028-2 (Paperback)
978-1-78277-163-0 (PDF eBook)
978-1-78277-164-7 (ePub eBook)
978-1-78277-165-4 (Kindle eBook)

All rights reserved. No part of this publication may be reproduced, stored in a retrieval system, or transmitted in any form or by any means, electronic, mechanical, photocopying, recording or otherwise, without the prior permission of the copyright owner.

The opinions expressed in this publication are those of the author and do not necessarily reflect the views of the UCL Institute of Education, University College London.

Typeset by Quadrant Infotech (India) Pvt Ltd
Printed by ImageData Group Limited

Biography

Andrew Burn is Professor of English, Drama and Media at the UCL Institute of Education, and director of the DARE centre (Digital | Arts | Research | Education), a research collaboration with the British Film Institute. He has published work on many aspects of the media, including media literacy in schools, the semiotics of the moving image and computer games, young people's production of digital animation, film and computer games, and media-related play. He is director of MAGiCAL Projects, an R&D enterprise developing and marketing games-based software, including the popular game-authoring tool Missionmaker. Previously he taught English, Drama and Media Studies in comprehensive schools for over twenty years. He was Assistant Principal at his last school, Parkside Community College in Cambridge, where his main role was to direct the school's media arts specialism: it was the first specialist Media Arts College in the UK.

Acknowledgements

I am grateful to those who have taught me most, both in my teaching career and academic career, especially Ken Jones, Gunther Kress and David Buckingham. I am equally indebted to colleagues with whom I have collaborated in projects referred to in this essay, for their generosity and insight, especially James Durran, John Potter, Mark Reid, Diane Carr, Alison Gazzard, Abel Drew, Andrew Kennedy, Theo Bryer, Jane Coles, Morlette Lindsay, Richard North, Vicky Symons, Stella Wisdom and Carey Jewitt; and for the perspicacity of PhD students, especially Bruno de Paula and Daniel Ferreira. I owe a debt of gratitude to funders of the research projects described here: to the Arts and Humanities Research Council (Playing Beowulf: Gaming the Library and Playing Shakespeare); to First Light (Montage, Mash-up, Machinima); and to partner institutions: Shakespeare's Globe, the British Library, Moviestorm Ltd, and Coleridge Community College. Most importantly, I thank my partner Jenny Griffiths for her unfailing support and patience.

In defence of the media arts: Screen education in the twenty-first century

Introduction

A small group of 13-year-olds are making video games in a school computer lab in East London. To make the game they have to code each event using Boolean operators: IF the player enters the room / AND the spiked door is open / AND the bag of treasure is NOT active / THEN the warrior's state is aggressive / AND the medieval music's state is PLAY.

They have assembled their game-worlds: medieval chambers, dark caves, maze-like corridors. They have imported characters: kings, queens, warriors, monsters. They are choosing music to trigger at particular moments in the game; their choices range from Icelandic folk music to theme music from the popular medieval-styled AAA game *Skyrim*.

Their game is based on the Old English poem, *Beowulf*, and they are participating in a research project with my research group, the British Library, and a number of other partners. The project has helped us to answer a number of questions at the heart of arts education and, in particular, media arts education: how do different art forms connect in cultural forms like video games? How can games adapt literature? What has computer science to do with the media arts? What might young people's interests be in such a project, and what might they learn? These are some of the questions this lecture attempts to address.

At a time when arts education is again marginalized in school curricula – at least in schools in England – the media arts are most in danger of being lost. This lecture proposes six reasons why schools and policymakers should take the media arts more seriously. It argues for collaboration between the arts, proposing that in today's world a fusion of artistic practices is more common than a separation between them; and it challenges the hierarchy of the arts that operates in society and in education, taking its cue from wider practices of cultural distinction, as well as from curriculum policies that reflect, even

reinforce, such practices. Finally, it identifies the specific role of digital media in the media arts, arguing for continuity from the analogue age and from earlier cultural forms; and for innovation, in our approaches to the related processes of interpretation and creative production in the digital age.

There is a long history of knockabout debate over the arts – attack and defence, critique and apology, justification and rebuttal. Plato famously banned poetry from his imaginary Republic because it misrepresented the gods; Aristotle just as famously defended the virtues of poetry and drama. In the Renaissance, Sir Philip Sidney's *Defence of Poesie* took up the battle. Part of his argument was, as with Plato, about the paradoxical nature of fiction: that in inventing palpably false worlds populated by dragons and wizards, it could still somehow tell deeper truths about human nature. It is essentially Brecht's argument about realism. In doing this, Sidney ingeniously managed to get Plato off the hook by arguing that it was bad drama he was criticizing rather than drama or poetry itself.

The arguments are complex – about the nature of fiction, about the supposed ethical benefits of the arts, about the sensory pleasures of engaging with the arts; and a general humanist argument about the value of the arts as a means for human societies to represent themselves, construct their narratives, document, fantasize, dream. The debates continued through the Enlightenment, the Romantic movement, the Modernist aesthetic and today's debates, which in many ways are more or less direct descendants of the themes established by these earlier thinkers.

An example which struck me is John Carey's (2005) book, *What Good are the Arts?*, a rhetorical stance directly opposed to Sidney's, taking as its starting point a robust critique of the usual aesthetic, ethical, and humanist arguments. It's a valuable account in many ways, pricking the pretensions and class-ridden taste structures of the contemporary arts scene. However, it remains puzzled about how the energy of popular culture, which he bravely acknowledges, stacks up against the cultural value of the literature he has spent his life studying.

In many ways, to adapt Brian Sutton-Smith's (2001) well-known formulation of the ambiguity of play, this age-old debate is about the ambiguity of the arts. Are they serious or trivial? Work or play? Fiction or reality? Ethical or amoral? Childish or adult? Anarchic or civilizing? Purposeful or pointless? Populist or elitist? These are questions which Carey, with his customary acuity, probes at length.

The debate is also about cultural taste and society: how taste is formed in our families, schools, and peer groups; which commentariat we read and believe; and how the cool and uncool, the kitsch and elevated, the beautiful and the sublime (to invoke Kant's version of the debate, and Bourdieu's trenchant critique of it) are at least in part determined by social context, by time and place, class and choice, friend and foe (Kant, 1790/1952; Bourdieu, 1984). In this area of the debate, Carey is in less comfortable territory. He marvels at the power of mass culture and its love of popular tropes despised by the elite arts establishment; yet he ends up arguing for the pre-eminence of literature as the art form which can critically reflect upon itself, through the nature of language. This is easily disputed: critical rhetorics can be found in other semiotic modes, not least the visual. And, in any case, most of the arts (if not all) are multimodal: words are, after all, to be found in song, opera, film, dance, and video game; while pictures populate the pages of novels, the poetry of Blake, and the modern form of the graphic novel. In online cultures, such multimodal cohabiting of artistic modes is even more marked and distinctive, in the variant combinations available through user choice, and in the embedding of expressive artefacts in (equally multimodal) framing commentary.

But my job here is not to make a wholesale intervention in the defence of the arts debate in general. Rather, it is to identify the specific value of the media arts in the early twenty-first century; and even more specifically, how they might form part of the project of education. I have six proposals to make.

Crossing cultural divides

The first is about the nature of culture. Cultural distinctions have been with us in their most familiar form since the Enlightenment, and forms of popular culture have thrived in all ages. We can trace their histories from folk songs and stories, chapbooks and broadside ballads, Victorian melodrama, penny dreadfuls and music halls; through to the popular music of the twentieth century, the horror films of 1930s Universal Studios and the Hammer studio of the sixties and seventies, the horror comics of the fifties, to *Grand Theft Auto* and *Silent Hill*, the literature of Stephen King, J.K. Rowling, and George R.R. Martin, and the film and game franchises that spring from them.

When I was at school, popular culture was simply invisible in the curriculum, or else actively discouraged. I can remember reading a James Bond book disguised by the dust jacket of a Dickens novel at the boarding school I

went to – and that was in my own time. But I also remember how important popular culture was as a shadow-life below the curricular radar – the comic my granddad sent every week; watching *Dr Who* on Saturday night; playing the *Man from U.N.C.L.E.* with my friend Douglas, who had to fight me to be Illya Kuryakin every week.

When I became a teacher, I began teaching literature and drama with the zeal for great literature and dramatic art which English as a subject promoted like a kind of ideology in the era of Leavis, whose ghost still haunts the official curriculum. However, a good deal of what worked well in the classroom couldn't really be described as high art. The most successful text for reading out loud I ever used was George Layton's *The Fib*, with its evocative tales of 1950s boyhood, and its central narrative of the heavy burden of the child's lie to shut the bully up – that his uncle was Bobby Charlton, the legendary Manchester United forward.

In teaching poetry, promoting the virtues of Robert Frost, Ted Hughes, John Agard, and Grace Hallworth, I was brought up short one day by the Pett twins, two alarming 15-year-old metal fans, in one of my classes. James asked if Meat Loaf's 'Bat out of Hell' could count as a poem for their CSE coursework. I'd never heard of it – but anything seemed worth trying – and I was amazed by the energy that suddenly flooded through the classroom; how keen they were to write about it, how attentive they were to the simile ('Like a bat out of hell I'll be gone when the morning comes'); how, after this negotiation, they were noticeably more enthusiastic about the more conventional fare I was putting in front of them.

In the critical project of the arts curriculum, the case for taking popular culture seriously is most effectively made by media educators in higher education and schools. It is informed by Raymond Williams's (1961) powerful vision of a common culture, a lived culture, in which the daily practices of working-class families deserved to be taken as seriously as those of the opera-going class.

However, it has become more complicated, in two senses, than it was in the early days of cultural studies in the UK. First, the postmodern hypothesis – whatever its excesses, pessimisms, and misplaced suspicion of depthlessness in contemporary culture – productively proposed a collapsing of the formerly well-policed boundaries between high art and popular culture. This collapse is, of course, itself ambiguous, as those boundaries are still policed quite effectively. Nevertheless, where they crumble, even a little, we can see real opportunities

for education. Where the art of Shakespeare meets the MTV aesthetic in Baz Luhrmann's *Romeo + Juliet*, for example, we find unlikely aesthetic conjunctions and abrupt meetings of taste communities that would once have had nothing to do with one another. Indeed, I can remember teaching *Romeo and Juliet* to a very reluctant 13-year-old school refuser, for whom the merging of the figures of Romeo and Leonardo di Caprio was a particular kind of magic. Watching the film produced a potent mix of English lesson and fandom; but the media project of making a trailer for the film – where she could get her hands on the pliable stuff of the digital moving image and rework it – offered a form of agency which seemed, at the time, like a startling shift of power from media institution to audience; though we have now learned to be more cautious about such claims.

The other sense in which things have changed is the culture which John Potter (2012) refers to as the new curatorship: how we now collect, archive, and create media as records, representations, interpretations, and exhibitions of our lives. From a different angle, the entity formerly known as 'the audience' (and before that, the 'mass audience'), is now routinely viewed as capable of media production. The research evidence is certainly clear that the proportion of young people engaging in substantial media production – such as editing films for Youtube, or making their own video games, or constructing durable websites – is still a minority, albeit perhaps a growing one. Rather more are curating their media artefacts, in Potter's sense. Nevertheless, it is the job of education to give all young people an experience of what a self-selected minority could accomplish left to their own devices (as indeed they often are).

When we take these ideas together – the value of popular culture, the blurring boundaries in late modernity between elite and popular cultural forms, the attention to popular culture typical of media education, the new curatorship – how do they all sit in relation to education and its ways of dealing with culture? If culture is, as Raymond Williams famously said, one of the two or three most complicated words in the English language, then it is unsurprising that its presence in education should be unclear, opaque, and contradictory.

In the English national curriculum, it's hard to find any clear sense of what culture has meant. Broadly speaking, it has generally referred to two things: multiculturalism and heritage culture. In relation to the arts more generally, the Henley Review commissioned by the Department for Education and the Department for Culture, Media and Sport had a stab at explaining it, illustrating it, even prescribing it (DCMS/DfE, 2012). What emerged was a

hierarchy of the arts. At the top of the heap was music and art, reinforcing their already elevated status as national curriculum subjects. Next came dance and drama, currently subsumed under, respectively, PE and English. Henley recommended they become subjects in their own right – a recommendation kicked into touch by the government. Next came the one concession to media education: film education, which reflected the successful lobbying of British Film Institute (BFI) education and the BFI's lottery distribution role. Although Henley's pitch here was for cinema as heritage culture, rather than as popular culture (and again, my argument is that the two are best promoted together rather than as polarized opposites), this was a step forward, and was also distinguished by an attention to the making of film by young people as well as its viewing and critical appreciation.

However, the scandal of Henley was its complete omission of any mention of media education more broadly conceived, or of media studies, despite its palpable success in terms of take-up at GCSE and A Level, as well as its long history of catering for the cultural interests of generations of young people, and its distinguished record in the UK, admired around the world, but repeatedly snubbed or downplayed by successive British governments and sections of the media.

Education in new screen media, then, has the potential to pay proper attention to popular culture, to explore cultural taste and value, and to productively erode old polarities between elite and popular cultures. It is not necessarily unique in this respect: good work does exist in music, art, and dance education that bridges this gap. Nevertheless, media educators start from popular culture, which routinely foregrounds comics, video games, soap opera, and popular cinema – the material of 'trash' culture that the other arts have to battle to include.

Time travel

My second argument for the value of media arts education lies in the sense in which cultural and textual histories can be explored though new screen media. The argument here is a critique of the notion that contemporary popular culture is a culture of rupture – that the new screen media of computer games, music videos, and CGI action films violently break with the past and with what Matthew Arnold famously (or notoriously) described as 'the best which

has been thought and said' (1869/2009). This conception of the digital age is essentially neophilistic: a view of digital technologies as always new, sparkling, novel. In spite of its scientific gloss, it is really a kind of magical thinking, in which newness itself is the guarantor of miraculous transformation, and the detritus of the old is swept briskly away. It can be discerned in the very phrase 'new media', as if digital film, machinima, games, and social media didn't owe their cultural shaping to older forms of the moving image, of ancient games or archaic narratives, or of social communication from diaries to telephones.

Rather, we might productively consider how the digital arts can enter into dialogue with their antecedents, a dialogue in the Bakhtinian sense, in which utterances respond to earlier utterances and address future ones, and also engage with their own historical moment; in Bakhtin's words, '[brushing] up against thousands of living dialogic threads' (1952/1981).

We can note how the structures, imagery, rhythms, and narratives of contemporary screen culture are more firmly rooted in older – even ancient – traditions than we might realize. The origins of the three-minute pop song in Dowland and Schubert is one line that could be traced – though I will not attempt it in any detail, musicology being beyond my professional scope. Another line of pursuit is video games, where the formulaic structures of adventure games or role-playing games in which you, as protagonist, face a series of ever more powerful end-of-level boss monsters, have oral narratives like the *Iliad* or *Beowulf* as their predecessors. Indeed, *Beowulf* has now been made into an animated film and, subsequently, a video game in which you successively battle Grendel, Grendel's mother, and finally, the dragon, their life-force and yours emblazoned across the screen as game economies. We have recently conducted a research project with the British Library to develop a game-authoring tool for *Beowulf*, in which these principles are enacted in game design by young people.

The argument here, then, is that games provide a particular kind of cultural continuity, recalling archaic forms of narrative, even reconstituting something of the sensibility of oral cultures – a version of Walter Ong's (1982) idea of secondary orality.

Why is this a good thing? If the role of the arts in education is indeed to introduce students to heritage culture, these examples suggest that games, despite being the newest media form, can also 'do' heritage: that is, reach back into traditions of narrative that pre-date modern distinctions of taste, and revive the vitality of those narratives and their vivid, visceral representations

of perennial human concerns. Nobody would argue with a class's enjoyment of a good book, musical composition, watercolour, or piece of theatre. The same argument has effectively been made for watching film, and considerable sums of money have been spent promoting this in recent years. Why not, by extension, promote playing a video game as a collective class experience? One of my earliest research efforts in this field was to study the Year 7 class of my colleague, James Durran, while playing the video game of *Harry Potter and the Chamber of Secrets*, and noting not only the intense collective pleasure in this experience of fiction, but also the potential for critical interpretation, by the class, of the meaning of Harry Potter and his world, the narrative structures of the game in comparison with the book and film, and the critical interrogation of the media industries behind the franchise, through the text and logos on the game box.

And, to return to the heritage argument, if the Harry Potter books produce interesting questions about meaning and narrative when adapted into video game format, what would happen if we did the same thing to a Shakespeare play? It would produce a new kind of Shakespeare, familiar to a twenty-first-century audience. However, it might also make possible a different reading of Shakespeare: one that emphasized ludic qualities already present in the texts. Some examples: the magic wood, potions, identity-swapping, and win–lose outcomes of *A Midsummer Night's Dream*; the conditional logic of Hamlet's progress (if it's my father's ghost I'll revenge it; if it's a demon from hell, I'll repel it; if I kill Claudius at prayer, he'll go to heaven; if I kill him with his sins upon his head, he'll go to hell; if I kill myself, I lose these burdens; if not, I face up to my responsibilities); or the moment at the end of *The Tempest* when Prospero turns to the audience and tells them that they decide whether he remains on the island or gets back to Milan – which is the second-person mode of address characteristic of video games.

With all this in mind, let's consider a sequence from a game of *Macbeth* made by two 13-year-old girls from a school in Cambridge. They made it on our game-authoring software Missionmaker (now owned by UCL Institute of Education, and developed by MAGiCAL Projects at the London Knowledge Lab), in partnership with Shakespeare's Globe. When we developed the *Macbeth* game tool, the Globe was very insistent on certain features: the hallowed text, unsurprisingly, and blood – obviously an important element of *Macbeth*.

Rather surprisingly, however, the students didn't always focus on the blood. One pair chose to use sewer environments in the software to represent the 'sewers of Lady Macbeth's mind' (Figure 1) – an elaborate visual metaphor.

In defence of the media arts

Figure 1: Screenshot from the Year 9 *Macbeth* video game showing 'the sewers of Lady Macbeth's mind'

We also created a game economy tool. Economies are quantified elements in a game, experienced by the player as assets that can be managed in various ways. Common examples are time, health, power, ammunition, and currency. The Missionmaker software already had three economies – health, strength, and hunger – so that students designing games could program these to respond to events they created. We decided to take off the labels, so that the students could call these economies anything they liked. They named them after qualities relevant to the play – such as bloodthirstiness (Figure 2), ambition, and conscience – and programmed them to rise or fall depending on the player's decisions.

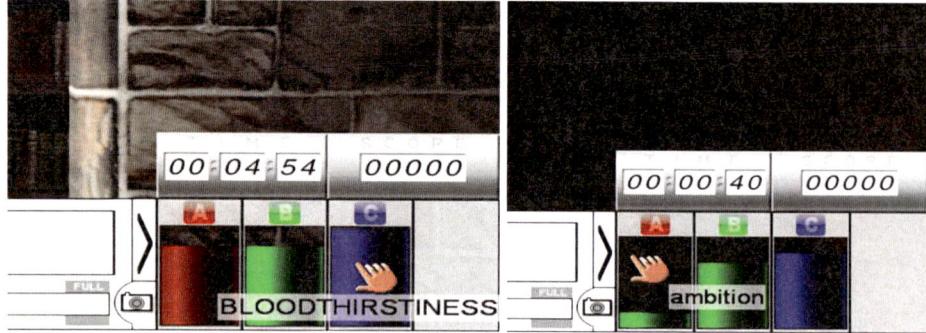

Figure 2: Screenshot from the Year 9 *Macbeth* video game showing the economies

This construction of the psychology of the characters through game economies may seem, at first glance, offensively reductive to the sensibilities of literary scholars, or English teachers, accustomed to viewing such textual features as organic, nuanced, and elusive qualities. However, the economies effectively emphasize the constructedness of such qualities; and when we look back at the text of the play, it is remarkable how often qualities like pity, ruthlessness, and femininity, are represented in images of liquid quantity: blood; the milk of human kindness; the liquid of 'direst cruelty'.

We also observed how the architecture of the games made it possible for students to rework the text productively in different ways. One pair of girls, fascinated by the witches, but charged with making the game level of Duncan's murder, reintroduced the witches, making them ghostly reminders of the prophecies immediately before the player as Macbeth commits the murder. They also rearranged the building, placing Duncan's bedchamber in the basement – perhaps suggesting the moral debasement of the murder – and the witches in the upstairs chamber, maybe a supernatural realm. Whatever the significance might be, to interpret Shakespeare through a manipulation of time and space in this way would be challenging in the conventional English classroom.

Screen media like games, then, might enable new kinds of communicative and creative skills in students, and represent new digital cultures; but they also connect with older cultural forms, and allow us to see them in new ways. The video game industry has barely exploited the back catalogue of English literature, in the way that Japanese games have built on samurai legend and Shinto and Buddhist myth. Indeed, in our research project with *Beowulf*, working with Anglo-Saxon scholars at UCL and with digital

In defence of the media arts

curators at the British Library, the activity of game design showed how students were able to construct interactive digital dramas that interpreted aspects of the poem, such as the meaning of combat, the ambiguity of monsters, and the representation of women in medieval narratives.

The final point of interest in these examples of game design is that students made their games by constructing rules: an elementary form of coding. Figure 3 shows a screenshot from the *Macbeth* game made by the two girls. At the bottom of the screen is the 'rule editor', showing one of the rules made by the girls: 'If Crown's state / becomes "Owned by Player" / Player gains 500 Economy A points.'

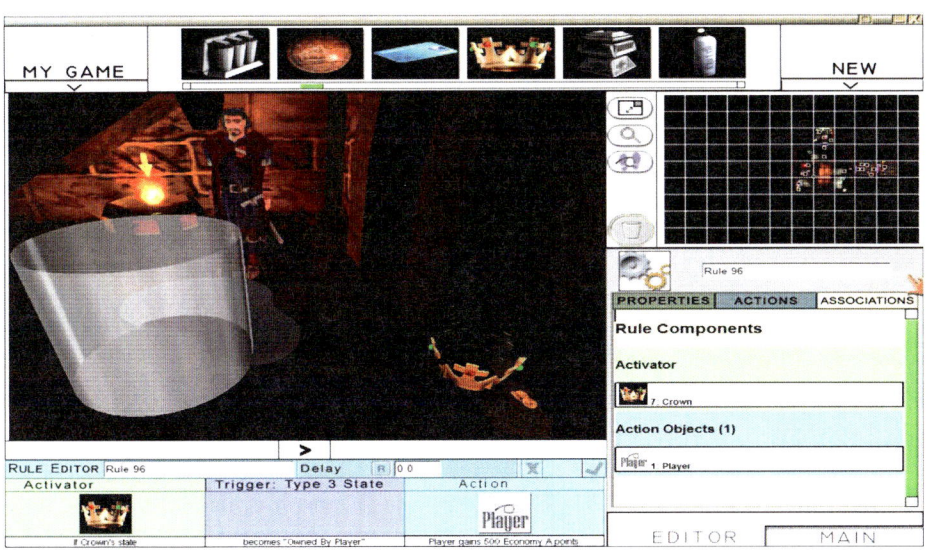

Figure 3: Screenshot of the *Macbeth* game showing an example of a rule

Economy A has been labelled by the girls as 'ambition', so this rule relates to the quantity of ambition to the symbolic properties of the crown. The key characteristic of this procedural design is that it must produce conditionality – all programmed events depend on player interaction. This produces a particular kind of procedural narrative typical of video games, and it can be analysed in relation to the meanings of the game. In this case, for example, the player might choose to seize the crown after killing Duncan, eager to fulfil the ambition of the character, and hoping thereby to set in train a sequence of events leading to kingship – which could indeed be further programmed consequences in

this case. Alternatively, the player might decide that they are overcome with remorse, and flee the scene, ignoring such rewards, and setting a different chain of events in motion. These articulations of rule-governed behaviours and multiple routes through a text are characteristic of procedural authoring. As a matter of interest, some argue that such procedurality is not unique to video games; only that they produce the effect through the automated processes of the computers, thus allowing a quantitative leap in what is possible (Ferreira, 2015; Bogost, 2006).

To code Shakespeare or *Beowulf* might seem an odd form of textual interrogation or adaptation. Nevertheless, it may be less incompatible with the nature of narrative and poetry than it seems. After all, the elements of an orally-composed narrative (as *Beowulf* appears to have been at least in part) are effectively formulae, available for reuse and recomposition to the poet – much as segments of code might be to the game designer, or formulaic sequences might be to the game-player. A character in a game is an assemblage of media assets held together by animations and algorithms; but a character in literature might be said to be made up of linguistic segments animated by verbs and by the narrative algorithm, especially in an oral narrative.

To adapt literary texts through code makes it possible to connect the arts curriculum with the (computer) science curriculum – that is, the insertion of the arts into the STEM subjects (science, technology, engineering, and maths), which is now familiar to us through the STEAM acronym. I will return to this theme in the final section. For the purposes of this section, the notable feature of code is its compositional similarity to the oral-formulaic processes of archaic narratives, and its function in enabling the productive connection here between ancient cultures and the digital era.

The new rhetoric

The arts are generally good at attending to creativity and aesthetic form. The media arts have traditionally been better at critical interrogation of various kinds. Media education has always been a form of critical practice, as in the forms of 'critical literacy' propounded today, which encourage students to question 'who constructs the texts whose representations are dominant in a particular culture at a particular time; how readers come to be complicit with the persuasive ideologies of texts; whose interests would be served by such representations and such readings …' (Morgan, 1997).

In another game-making project, for example, we asked 12-year-old students to invent a games company for their game, to think about who might contribute to the game, how to market it (Figure 4), who would review it, and who would buy and play it.

Figure 4: A poster made by a student promoting the class's video game

These critical explorations of who lies behind media texts, of the political economy that frames their production, and of the audience's pleasures, tastes and engagement which respond to them, isn't often found elsewhere in arts education. This kind of work can be seen as the rhetorical aspect of the media arts in schools. As is well known, Aristotle's model of rhetoric involved three artistic proofs or modes of persuasion: the *ethos* – or knowledge, authority and persuasive stance of the speaker; the *logos* – the words; and the *pathos* – the emotional appeal to the audience. I mention these ancient categories because they are still with us. The production regime in which a media text is generated, the structures of the text itself, and the reception regime in which audiences

engage with the text are three categories fundamental to contemporary conceptions of the cultural exchange of meanings in cultural studies (Du Gay et al., 2013). They are also fundamental to the conceptual framework employed by media educators: the bedrock of the critical understanding that students are expected to acquire.

There is a history of unease among media educators, however, about what happens when this critical approach becomes isolated from the pleasures of engaging with the media or the creative enjoyment of media production. At the level of public examinations in the UK (at GCSE and A Level), conceptual and critical understanding is often assessed through written essays that analyse media texts or evaluate the students' own production work. It is all too easy for such work to become a decontextualized, dutiful rehearsal of what the student imagines the teacher or examiner wants to hear (Buckingham et al., 2000). Part of the solution to this problem has often been seen as a closer integration between creative work and critical understanding. In the examples given above, critical understanding of institutions and audiences is combined with the creative processes of journalistic role-play and poster design.

While this is a relatively light-hearted example, the students have also been encouraged to consider various aspects of the games industry (studio production, games magazines, games retail outlets); the game's audiences; and the political message of a game itself, as well as the possibility of different audience interpretations. This has been accomplished in the form of a written role-play, integrated into a suite of activities around game production (writing walk-throughs; designing posters and game box covers; designing and producing the game itself with an authoring software package), rather than an abstract activity divorced from the creative context.

In some ways, this kind of activity resembles the 'crit' of art education – the tradition of oral critique in which students and teachers critically appraise students' work. The main difference in media education is the focus on the rhetorical function of the text, the intentions of its producers, and the interpretative work of its audiences.

The new poetics

However, the media arts are not only a tool to promote critical thinking. They also have an aesthetic function, like all the arts – indeed, like any designed

object or performance. What might this be? What is distinctive about the aesthetics of digital screen media?

Two brief anecdotes may suggest something of the changing aesthetic concerns of screen media. One came to my attention from a PhD student completing a study of Tacita Dean's installation at the Tate Modern, called *Film*. The point of this artwork is a denial of the digital, a celebration of analogue celluloid film, its grain and flicker, its scratches and sprocket holes. The other story is of another student, an artist and animator, who a while ago established herself in the virtual world *Second Life*, digitized her paintings, and put them on show in a virtual gallery. Looking at them, she wrote about how new and bright they seemed – rather than what pale imitations they were.

These contestations over the nature of screen media are partly to do with what Rebecca Sinker (2000) once called the 'digital aesthetic' and its screen surface and pixellated layers; but partly about the work of art as a machine-made product. These are descendants of the concerns Walter Benjamin famously discussed in *The Work of Art in the Age of Mechanical Reproduction* (1936/1968); and my concern here is not to provide answers, but to argue that these are aesthetic concerns to do with taste and judgement as well as aesthetic form – and educators need to provide opportunities for students to explore them. For painting, music, sculpture, drama, and dance, this may be largely a question of the transposition of physical arts into digital form. For the screen media arts, no such transposition exists: these are mechanical, digital media from the start, and their peculiar aesthetic needs no apology, though it might need better understanding. Their other distinctive feature is, as Benjamin anticipated, a democratization of the arts. The Shakespeare game is an example, not only of how students might remake Shakespeare rather than only reading and analysing him, but also how 13-year-olds can now make the video games that once only powerful industries could produce.

There are two points to make about this democratization. First, the tools do bring semi-professional production within the grasp of everyone, in principle (allowing, admittedly, for the digital divide). Second, however, while to some extent they contain their own play-and-go pedagogy, they do require hard work to produce something really good. We know from recent research that despite the ubiquity of media production tools, the proportion of young people publishing sophisticated content online is still a minority. So, there's still a role for education to level the playing field, and to give all young people a taste of the creative processes they may wish to develop later.

The aesthetic practices that education might foster through the media arts are, then, a complex mix. Media educators at their best work as taste-mediators, managing a multitude of cultural experiences and preferences that jostle against each other in the classroom, nurturing dialogue about them, and encouraging students to engage with new pleasures. But in making their own media, these tastes – these learnt and emergent perceptions of how shape relates to meaning – are applied to their own digital artefacts. This process is well described by Vygotsky's model of creativity in adolescence: the imaginative transformation of cultural resources characteristic of play, subordinated to rational thought (1931/1998). But it also recalls the artisanal craft described by Heidegger, where mere technical skills are elevated to a revealing of truth, a process I have referred to elsewhere, borrowing Heidegger's term, as 'digital aletheia' (Burn, 2016). These truths are not essences in Heidegger's sense, but mutable expressions of how young makers of film, animation, and video game see their world and the people in it; how they judge some representations to be more credible than others; and how they sense some shapings of such representations to be better formed than others.

Multimodality, cross-arts work, and the inside-out curriculum

There is a perennial struggle in the arts between purity and promiscuity: to keep painting – or music, or drama, or poetry, or film – ring-fenced; or to allow them to merge, overlap, converge. Again, I think we can have the best of both worlds here. Of course we need teachers, academics, and practitioners who specialize – who have deep knowledge of these domains of knowledge, and who know how to convey and develop these understandings with students at whatever level. But the challenge of multimodality – as a fact of the world and as a theory – is to realize also that the actual artistic and communicative practices of the world don't respect boundaries; and that in the digital age, we are more likely to see what we popularly know as remix and mashup. But these are not the only novel mixes – it has always been like this. Again, my focus is on what's distinctive about the screen media arts – and here it's that they are particularly combinatory. Take film as an example: from the first creative explosion of film-making, the Soviet film-maker and theorist Sergei Eisenstein (1968) argued, in his montage theory, that film not only radically juxtaposed images through editing, but also through the actor's changes of expression and gesture, and through the combination of image, speech, sound, and

music. Eisenstein's montage is a clear antecedent of today's multimodality. We can also say that the combination of modes is not only a consequence of the contemporary cultural form in question (in this case, film), but also of its cultural and technological history: its emergence from theatre, opera, music hall, stage magic, and optical illusion.

Let's look at another example of this in practice: a film by a group of thirty 11-year-olds. The film is machinima – the new form of animation that grew out of video games – and it's made using the 3-D animation software Moviestorm, as part of a collaboration with the BFI and the University of Leeds, funded by First Light. Machinima, as has often been noted, is a portmanteau word combining machine and cinema, with a substitution of the 'e' by an 'i', implying animation and animé. It is defined by Kelland *et al.* (2005) as 'the art of making animated films within a realtime 3-D environment'. It can be thought of as animation made from the 3-D environments and animated characters of computer games or virtual immersive worlds. The first machinima films were produced by players of the game *Quake* in the mid-1990s.

In order to make the film, the children developed their own narrative. They then split into different groups to make assets for the film itself. One group consisted of speech-actors who recorded the dialogue. One group designed the characters: their faces, costumes, expressions, hair. One designed sets: the landscapes, buildings, vegetation, skies, fire, objects. And the fourth composed, played, and recorded the music.

They then reformed into editing pairs, and each pair was responsible for editing a short sequence for the final film. Here, they placed the characters in the sets, animated them, added the dialogue, and crafted the moving image grammar of shot distance, angle, duration, and order.

One instance from the making of the *Moonstone* film will serve as a detailed example of the nature of multimodal design in this project. In the completed film, it appears as the brief scene from the opening minute, in which the heroine, Lily, answers the door of her house to see a police officer who has the difficult task of breaking the news that her parents' plane has crashed. The processes of composition leading up to this finished sequence are revealing. The visual scene was designed by two girls, working with three sets of resources: the set design of Lily's house and the street beyond it; the characters (Lily, her friend, and the policeman); and the pre-recorded voice-acting of the children playing the parts of the three characters.

The voice of the policeman is acted by a boy, who described in interview the specific function of the role. He is very conscious of the affective

charge of the vocal performance – a combination of reluctance and distress: 'You don't really want to tell her, but you have to 'cos it's your job really. 'Cos it's a bit upsetting to tell someone that their parents might be dead.' He relates this function to similar signification in other modes: facial expression and bodily action. His job is the traditional role of the voiceover artist, which in many ways has remained unchanged in the production practices of animation since its early days. From Disney through to Pixar, voiceover acting is recorded in advance, and the animation made to fit the voice, rather than the other way round. In multimodal terms, the modes of voice and body action, unified in 'live' drama, are segregated and put back together in post-production. The voice retains its nature as dramatic performance, an embodied realization of character through intonation, dynamics of tempo and volume, and vocal timbre. By contrast, physical action – gesture and facial expression – is of course designed visually as a simulation of performance. Nevertheless, the boy is aware of the relationship between the modes, for two reasons. First, he attends an after-school drama club, and is conscious, as the interview shows, of the relationship between drama and media; that fictional narratives in film involve the same kind of embodied expression as drama. Second, since he is, like the girls, editing a sequence of the film with other resources, he has experienced the importance of constructing a complementary relationship between the modes.

These insights are not trivial: indeed, they have a particular significance in the pedagogy of media education. The fragmentation of the curriculum into subject domains cuts across the multimodal relationships of authentic cultural forms, such as film and games, and each domain tends to privilege its own modes. Media education (like film and media studies in higher education) is likely to emphasize the orchestrating modes of filming and editing (Burn, 2013), and to under-emphasize (even neglect) important contributory modes such as dramatic action and voice. This constrained emphasis may occur in the day-to-day creative production work of teachers and children, at least in part as a result of the conceptual frameworks they are likely to inherit from curriculum and examination designers. To make life more complicated, it is not the case that such specialist expertise should be abandoned. The film educator is necessarily expert in the art of filming and editing; the music educator in melody and harmony; the drama educator in embodied action and voice. It is a question of how each can become sufficiently aware of one another's domain, sufficiently collaborative at the right moment, and sufficiently creative in overcoming subject domain silos when necessary.

In terms of the boy's vocal performance, he delivers the lines with appropriate choice of intonation, volume, and pace. Although the lines are scripted, he introduces three hesitation indicators: 'um', a repetition of 'I've', and a pause (Table 1, shot 3). To return to the sequence of composition in the film, we can see in Table 1 how the girls have constructed the sequence as four shots.

Table 1: Multimodal analysis of Lily and the policeman

Shot	Framing and camera	Action	Speech	Gesture	Face	Music
1	Mid two-shot (Lily and friend) from behind Lily	Lily goes to open door		Door opens	(Back of head)	Guitar and bass loop
2	Close-up two-shot (Lily and officer) from behind Lily	Lily opens door, revealing officer	Officer: 'Is one of you Lily Woods?' Lily: 'Yes, that's me.'	Officer waves right arm	Officer's face neutral	Solo violin descending minor arpeggios
3	Extreme close-up (officer's face); camera pulls back to close-up (head and shoulders)	Officer gives the news	Officer: 'Well, um, I've, I've come to tell you that [pause] the plane that your mum and dad were on has crashed, or has gone missing …'	Officer bows head and raises it again	Officer's eyebrows raise in the centre; eyes widen	Violin continues …
4	Mid two-shot reaction (Lily and friend)	Lily weeps, comforted by friend	'… over the National Forest.'	Lily covers face; she and friend turn to each other	Lily's eyebrows raise; mouth turns down	Violin continues …

The compositional process has begun, then, with the designing of assets as described above. Another student has been responsible for building Lily and the police officer, progressing through the layers of composition in Moviemaker to construct face shape, hair, eyes, eyebrows, nose, mouth, clothing, and so on. The job of the girls here is to build the moving image sequence on the editing

track of the software: organizing it into shots by inserting cut points; reframing the image with a virtual camera to change point-of-view, shot distance, angle, camera movement; and deciding how to represent actions and speech – which character to show when, and how. In many ways, this orchestrating work of the mode of editing is similar to such work in conventional film. It involves, for example, learning the purpose and structure of shot-reverse-shot sequences to represent conversation, as the other groups in the project learned.

However, the nature both of machinima and of this particular authoring tool, Moviestorm, produces some differences, both from live action film and from conventional animation. The girls viewed the sequence in the rough edit of the whole film, and noticed that the policeman's expression did not convey the appropriate sentiment for his words. Aware of the mismatch between the modes, they amended the facial expression of the police officer, going into the relevant Moviestorm menus to find the slider tools to change the eyes, mouth, and eyebrows.

This piece of compositional redrafting is distinctively digital. It would not be possible in live action film without re-shooting part of the scene, nor in cel animation without redrawing the cels. Nor would it be possible in conventional machinima without re-enacting the sequence with the virtual actors in the virtual world. However, the machinima here is really a blend of machinima and 3-D animation, and has the options of 3-D animation to rework the character on the fly, digging through the laminates to the layers that need adjusting. In semiotic terms, it consists of reworking the kineikonic syntagm (Burn, 2013) through paradigmatic substitution, making a closer intermodal match between the sorrowful intonation of the vocal track and the relevant parts of the facial expression (Figure 5). There is a selection of paradigmatic elements in play: replacing, in this child's words, 'straight' with 'all sort of sad'; bypassing a simple repertoire of 'sad, angry, and happy, romantic and stuff'; and working with a finer granularity of individual features. Such adjustments have similarities to the adjustment of lighting, audio volume, shot angle, and so on in the semiotics of film, in that they are distributed across a numerical scale. The film semiotician Christian Metz (1974) argued that such elements could not properly be considered part of the 'grammar' of film, since they are continuous scales rather than paradigmatic elements. However, we may dispute this because of the perceptions of the human sign-makers, and the ways in which they realize degrees of the scale in language. This produces something more like paradigmatic choices: camera angles, though adjustable on a continuous scale, become low shot, high shot, bird's-eye shot, and so on. Lighting becomes

In defence of the media arts

high or low, hard or soft, top or below, key, fill or back. Similarly, in these girls' choices, the slider scale filter for the policeman's eyebrows represents choices between neutral and sad.

Figure 5: The girls' design of the policeman

The final layer to consider is the music layer. This was composed by another group, using acoustic guitar, synthesized electric bass, and violin. The first sequence – which begins the film, continues through Lily and Kelly's conversation, and stops when Lily opens the door at the end of shot 1 – is a repeated two-bar finger-picked ostinato, or repeated melodic pattern, with a bass line that suggests minor chords and, at one point (bar 2), a discord. The use of ostinato in film music is ambiguous: on the one hand, it can provide a dynamic, driving, insistent quality; on the other hand, it can stabilize, or even lead to monotony. This ambiguity is well-suited to this scene: nothing out of the ordinary is happening yet, so the scene is in this sense stable; yet we are

made aware of an impending crisis. The effect is of muted disquiet, appropriate for the dramatic mood of the piece, and anticipatory of the bad news to come (Figure 6).

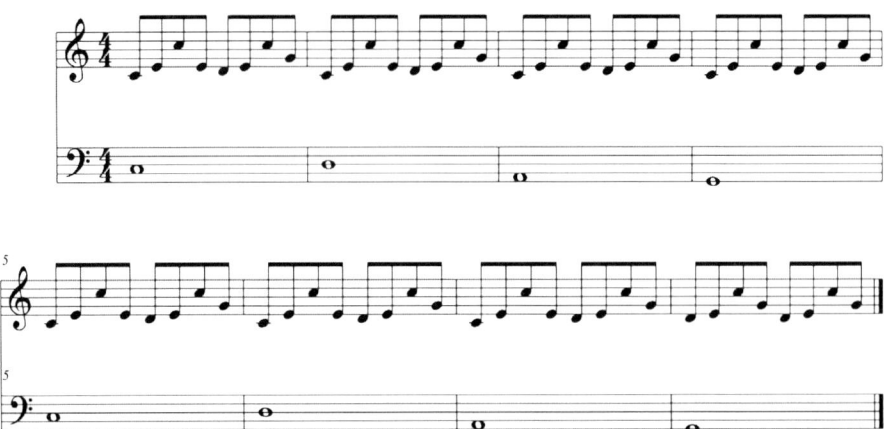

Figure 6: The ostinato sequence accompanying screenshot 1

The second sequence, which begins as the policeman starts speaking, is a soulful descending series of notes in a minor key, played on a solo violin. Minor keys traditionally signify sadness, of course, while the melodic descent happens in steps; each bar descends, rises a little in the successive bar before descending further, and so on, so that an effect of a struggle against descent is conveyed. It has a baroque quality, accentuated by a trill on the penultimate note, a typical ornament of the baroque, suggestive of emotion (as in the music of Bach) (Figure 7). Here, the clear intention is to convey the tragic quality of the policeman's message.

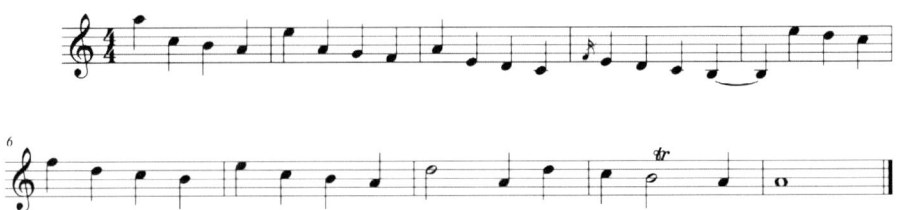

Figure 7: The solo violin sequence accompanying screenshots 2–4

The music as contributory mode is performing a range of functions in this sequence. The loop structure of the ostinato in the first section is reminiscent of video games and the unpredictable duration of their game-play sequences. It also indicates, in its uncertain oscillation between major and minor, the tension between the girls' ordinary evening at home and the growing anxiety caused by the parents' lateness.

The abrupt shift into the tragic, legato (smoothly-flowing) scales of the violin clearly complements the emotional charge of the policeman's message. Here, the tonality of the violin, the downward trajectory of the descending arpeggios, and the minor key all work to emphasize, through the mode of music, the representations carried by the vocal characteristics of the boy's performance, and the linguistic elements of the policeman's message.

This detailed analysis of the specific layers of vocal performance, visual design, and music composition reveals two orientations in terms of the semiotics of the moving image and its 'technologies of inscription', or material media (Kress and van Leeuwen, 1996). One orientation is towards the traditional lamination processes of animation: the bifurcation of vocal and bodily performance; the layering of visual imagery to produce the 'impossible image'; and, as we have also seen, the additional layer of musical signification, common to all forms of moving image media since their inception. The other orientation is towards the 'language of new media' (Manovich, 1998): to the digital laminates of filters; the numerical scales of image adjustment, and the new paradigmatic choices they produce; and to the playful compositional regimes of video games and virtual worlds. We have also seen how this mix of practices requires the collaboration of educators with different specialisms across the arts: in drama, literacy, music, media education, and ICT.

There are three arguments about multimodality here. First, screen media have always been multimodal forms, and they incorporate other, older forms of artistic work: among them, the poetics and rhetorics of speech, visual design, dramatic action, music, and architecture. Second, they make cultural connections – here, between the 100-year-old culture of cinema and the more recent popular cultural form of video games. Third, this kind of project exemplifies, on the one hand, the value of specialist skills and domains of knowledge – from musicians, film-makers, English teachers, ICT specialists, and media educators – but also, on the other hand, the need for these to work together to produce the kind of media we're used to seeing on our screens today – on our TV and cinema screens, games consoles, and mobile phones.

Two consequences follow. One is about the need for cross-arts collaboration. We can specialize, but ultimately we need to collaborate and learn to speak each other's languages. The other is about curriculum design. This kind of project depends on a background of specialist teaching and learning, with the children building on their English, drama, music, and ICT lessons. But to make something memorable like this happen, you have to be able to collapse the subject-silos that national curricula worldwide typically enforce. To put it another way, we can imagine the curriculum as a series of concentric circles. In the centre are the much-prized core skills – literacy, numeracy, scientific and computational thinking, and so on. In the next circle out, there are the rather more disposable subjects; in the national curriculum, the arts, music, and art have occupied this space in recent debates about the so-called e-bacc in the UK, although a more recent formulation has allowed them back in. In the next circle, you have subjects which are perfectly well-recognized as disciplines or discrete domains of knowledge and practice in HE and in the world; but which, in the English national curriculum, have never been accorded this status. In England, dance is a subset of PE, and drama a subset of English, as we have seen. Meanwhile, as I have already noted, the phrases 'media education', 'media studies', or even 'media arts' were not even mentioned in the Henley Report (DCMS/DfE, 2012). This is despite the fact that the UK arguably leads the world in media education, and that its media industries – as the same government never tires of telling us – are characterized by their creativity, innovation, and economic success.

However, to return to this curriculum of concentric circles, there is one more – the outer circle, where all the stuff that doesn't fit into the curriculum gets put: the orchestras, chess clubs, animation clubs, school plays, madrigal groups, rock bands, street dance groups, life-drawing classes, girls' computer clubs, and so on. To wax anecdotal, briefly, when I look at what former students are doing now, I wonder what really lies behind it. Is the boy who's now acting with the RSC doing this because he was in my GCSE drama class, or because he played Mr Rochester in the school production of *Jane Eyre*? Is the boy who now owns his own TV company in London doing this because he did media studies GCSE with me, or because he filmed and edited the school production of *Noye's Fludde* and, quite lucratively, sold it to parents? Is the girl who now sings with Opera North doing it because of her music GCSE, or because she sang 'Maria' in our production of *West Side Story*? Of course, it's a combination of these things. But what would happen, I wonder, if we turned the circles inside out? If we put the projects at the centre – the memorable, collaborative processes, and the

things of lasting value which they make – and the skills on the outside, serving the projects? In the school in which I last taught, we developed integrated curriculum units that sought to do this. I think we found that, as long as these projects were limited to a small proportion of the year's work, everyone treated them as add-ons, not core business. I don't think we were ever quite brave enough to invest enough time in them: beyond a certain tipping-point, departments would lose so much discrete curriculum time that they would need to put their core business into these collaborative projects, make them more central to the whole school's enterprise. I think this might be a model of education generally, and the arts in particular, that could work better than the silos in which we currently operate. In this way, the official curriculum of skills and knowledge would be put to the service of authentic arts projects – a means to an end, rather than an end in themselves.

Beyond STEAM: Digital cultures and practices

When my last school, Parkside Community College, became the country's first media arts college in 1997, something odd happened. It was our moment of entry into the world of the digital arts. Previously we had used an analogue video editing system, which media educators of a particular generation will remember fondly. In the summer of 1997, we bought three high-spec Macs and the professional non-linear editing system Media 100. For many years we used this successfully, and learned a good deal about moving image literacies in the digital age (Burn and Durran, 2007).

But that wasn't the odd thing. What was strange was that the head of ICT in the school wouldn't go near the Macs and the editing software. Instead, he lived in his rival world of PCs and Microsoft Office, which occupied a good deal of the ICT curriculum. It's easy enough, with hindsight, to condemn that kind of curriculum, and the current wholesale rejection of it is the final expression of this condemnation – though quite what we put in its place is rather less clear.

I think something else was going on, in this sudden collision of media teachers and ICT teachers. Lev Manovich, in his classic book *The Language of New Media* (1998), tells a compelling story of the parallel histories of two technologies, both beginning in the 1830s. One begins with Babbage's proposal for the 'Analytical Engine', the ancestor of the computer as an information processor. The other begins with Daguerre's daguerreotype, the ancestor of the camera, as the basis of representational technologies over the

next two centuries. Manovich's argument is that there are two parallel layers: the computer layer and the culture layer, which eventually come together in today's multimedia computer. That, I think, was the moment when our Macs arrived, and it was a moment of mutual incomprehension. The head of ICT had no way to understand what it meant for information processors to become instruments of cultural production. But at the same time, we media teachers had no way to understand what it meant for the 100-year-old language of film to have become computable.

Fast forward to today. It seems to me that we are still in danger of falling into this divide; and it's a version of C.P. Snow's famous *Two Cultures* of the arts and sciences (Snow, 1959/2001). In 1959, at the Senate House in Cambridge, Snow put it like this:

> A good many times I have been present at gatherings of people who, by the standards of the traditional culture, are thought highly educated and who have with considerable gusto been expressing their incredulity at the illiteracy of scientists. Once or twice I have been provoked and have asked the company how many of them could describe the Second Law of Thermodynamics. The response was cold: it was also negative. Yet I was asking something which is the scientific equivalent of: Have you read a work of Shakespeare's?
>
> (Snow, 1959: 16)

I take his point. It's interesting that many contributing to the debate about programming in schools cannot themselves program. An example is Ian Livingstone, adviser to the government on the need for programming in schools. Livingstone makes the case powerfully in his *Next Gen* report for NESTA that we won't have a video games industry in the future if we don't teach children proper programming: to learn to make digital products rather than just to use them (Livingstone and Hope, 2011). But Livingstone is a storyteller, not a programmer, and if we look at his most famous creations – the *Fighting Fantasy* books of the late 1970s or the *Tomb Raider* series – we realize that storytelling is just as important as programming, and it's the effective fusion of the two that makes the difference.

So my worry is that the new programming could just become a tedious abstract discipline, with a tiny proportion of students finding their way eventually into the games industry or something similar, and the rest dying of boredom along the way. To be fair, Livingstone recognizes this danger, and

his formulation of it is the increasingly popular acronym STEAM, which puts the arts into the STEM subjects. My comment would be that this is a step in the right direction, but it doesn't go far enough to address Snow's original profound critique – it treats the arts as a minor player, a supplement to the formidable ranks of the 'serious' disciplines.

Perhaps we need a new acronym. John Potter (2012) has proposed STEAMM – an additional M to signify media. In any case, we need something that addresses the need to dissolve scientific and arts-based views of the world into each other, while still preserving their distinctive virtues. It is the old story of Leonardo's intermingling of science and art, technology and aesthetics, mathematical patterning and visual design. If you look at Livingstone's companies, Eidos and Square Enix, and the collaboration of disciplines they use to produce *Final Fantasy* or *Tomb Raider*, you see the game-world's version of this: computer science, software engineering, 3-D animation, speech acting, storytelling, music composition. It's the industry equivalent of the Year 7 group whose work is explored above – and an example of how, in the world of screen media, science and the arts go hand in hand, as they could do in the curriculum. More specifically, the game designs of *Macbeth* and *Beowulf* referred to above combine simple forms of programming with narrative re-imaginings of those texts. They are the coding of Shakespeare and *Beowulf* – a meeting of computer science and literary art through game design. If the curriculum could serve such projects, the kind of ideal indicated by STEAMM has a chance of success.

Conclusion: Martini media and a brave new world?

My argument, then, has been partly a defence of screen media education as a good in its own right. It is distinctive in its embrace of popular culture while extending across the whole range of cultural tastes and values. It is distinctive in its critical approach to contemporary media arts and communicative forms, offering a way to reinstate the rhetorical element of the liberal arts as they were constituted in antiquity and in the Renaissance. It is distinctive in its rich combination of signifying systems, media, and cultural traditions, offering opportunities for cross-arts collaboration that prepare students better for the way the arts work in society. And it is distinctive in being the art of the machine, both of the analogue and of the digital age, offering a bridge across the divide that C.P. Snow described, and which still threatens our culture and our education today.

Perhaps a final point to make might be the mobility that screen media offer to the artist. The typical set-up for the children who made the machinima film described above was of pairs of children at desks with desktop computers. Increasingly, that's not the only location and temporality for media-making. My own media over the last year have often been based on my iPhone: there is my photo collection; logo designs made on an art app; a draft multitracked edit of a Northumbrian pipe tune; edits of my Wordpress blogs. All these were edited in what used to be interstitial moments: standing on station platforms at King's Cross; sitting on the Tube; waiting in a shopping queue; sitting through a bit of downtime in a seminar or meeting. This is the Martini model of digital arts production – any time, any place, anywhere. But I'm cautious about ending with an over-celebratory note about digital media. I think there will be a new mobility, flexibility, adaptability; a new haptic disposition in design on touch-screens; but, also, still a need for studio-based work, professional environments, and training. As with the bridge between popular culture and high culture, between the individual arts and convergence culture, between curricular specialism and crossover, between serious programming and playful application, we can have our cake and eat it. But that's not to dilute the argument for the centrality of screen media in our arts and education. It's taken 100 years to get film education even to the margins of the curriculum. Let's not take another 100 years to get newer art forms such as video games and machinima to the same place.

References

Arnold, M. (1869/2009) *Culture and Anarchy*. Oxford: Oxford University Press.

Bakhtin, M.M. (1952/1981) *The Dialogic Imagination*. Austin, TX: University of Texas Press.

Benjamin, W. (1936/1968). *The Work of Art in the Age of Mechanical Reproduction*. Trans. Zohn, H. New York: Schocken Books.

Bogost, I. (2006) *Unit Operations: An approach to videogame criticism*. Cambridge, MA: MIT Press.

Bourdieu, P. (1984) *Distinction: A social critique of the judgment of taste*. London: Routledge.

Buckingham, D., Fraser, P., and Sefton-Green, J. (2000) 'Making the grade: Evaluating student production in media studies'. In Sinker, R. and Sefton-Green, J. (eds) *Evaluating Creativity: Making and learning by young people*. London and New York: Routledge, 129–53.

Burn, A. (2013) 'The kineikonic mode: Towards a multimodal approach to moving image media'. In Jewitt, C. (ed.) *The Routledge Handbook of Multimodal Analysis*. London: Routledge, 373–83.

— (2016) 'Digital aletheia: Technology, culture and the arts in education'. In King, A., Himonides, E., and Ruthmann, A. (eds) *The Routledge Companion to Music, Technology, and Education*. London: Routledge (forthcoming).

Burn, A. and Durran, J. (2007) *Media Literacy in Schools: Practice, production and progression*. London: Paul Chapman.

Carey, J. (2005) *What Good are the Arts?* London: Faber.

DCMS/DfE (2012) *Cultural Education in England* ('The Henley Report'). London: HMSO.

Du Gay, P., Hall, S., Janes, L., Mackay, H., Madsen, A., and Negus, K. (2013) *Doing Cultural Studies: The story of the Sony Walkman*. 2nd revised edition. London: Sage.

Eisenstein, S.M. (1968) *The Film Sense*. Trans. Layda, J. London: Faber and Faber.

Ferreira, D. (2015) 'The meaning potential of procedurality: Initial considerations on procedural semiotic resources'. Working paper: DARE, UCL Institute of Education.

Kant, I. (1790/1952) *The Critique of Judgment*. Trans. Meredith, J.C. Oxford: Oxford University Press.

Kelland, M., Morris, M., and Lloyd, D. (2005). *Machinima*. London: Course Technology PTR.

Kress, G. and van Leeuwen, T. (1996) *Reading Images: The grammar of visual design*. London: Routledge.

Livingstone, I. and Hope, A. (2011) *Next Gen: Transforming the UK into the world's leading talent hub for the video games and visual effects industries*. London: NESTA.

Manovich, L. (1998) *The Language of New Media*. Cambridge, MA: MIT Press.

Metz, C. (1974) *Film Language: A semiotics of the cinema*. Chicago: University of Chicago Press.

Morgan, W. (1997) *Critical Literacy in the Classroom: The art of the possible*. London: Routledge.

Ong, W. (1982) *Orality and Literacy: The technologizing of the word*. London: Methuen.

Potter, J. (2012) *Digital Media and Learner Identity: The new curatorship*. London: Palgrave Macmillan.

Sinker, R. (2000) 'Making multimedia: Evaluating young people's creative multimedia production'. In Sinker, R. and Sefton-Green, J. (eds) *Evaluating Creativity*. London: Routledge, 186–215.

Snow, C.P. (1959/2001) *The Two Cultures*. Cambridge: Cambridge University Press.

Sutton-Smith, B. (2001) *The Ambiguity of Play*. Boston: Harvard University Press.

Vygotsky, L.S. (1931/1998). *Imagination and Creativity in the Adolescent: The collected works of L.S. Vygotsky*. New York: Springer.

Williams, R. (1961) *The Long Revolution*. London: Chatto and Windus.

WITHDRAWN